INNER ARTIST COLORING BOOKS

12 Months of Wine Country
- A Coloring Book Calendar -
By Allison L. Thomson

© 2017 Allison L. Thomson

All rights reserved. No part of this book may be reproduced or transmitted by any form or means, electronic or mechanical, including but not limited to photocopy, recording, or any information or storage retrieval system, without prior, written consent from the author.

ISBN-13: 978-1979908047
ISBN-10: 1979908044

inner-artist@outlook.com

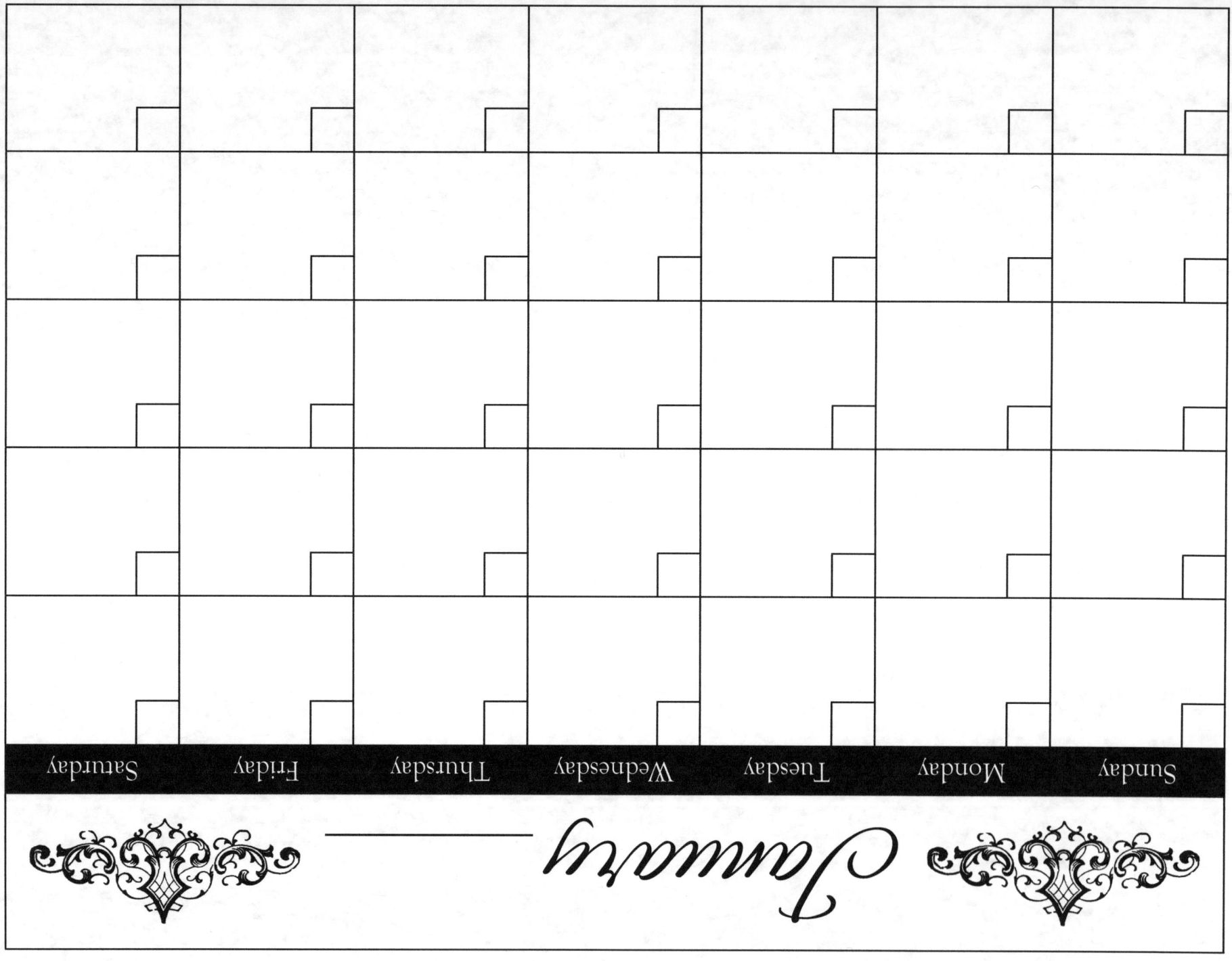

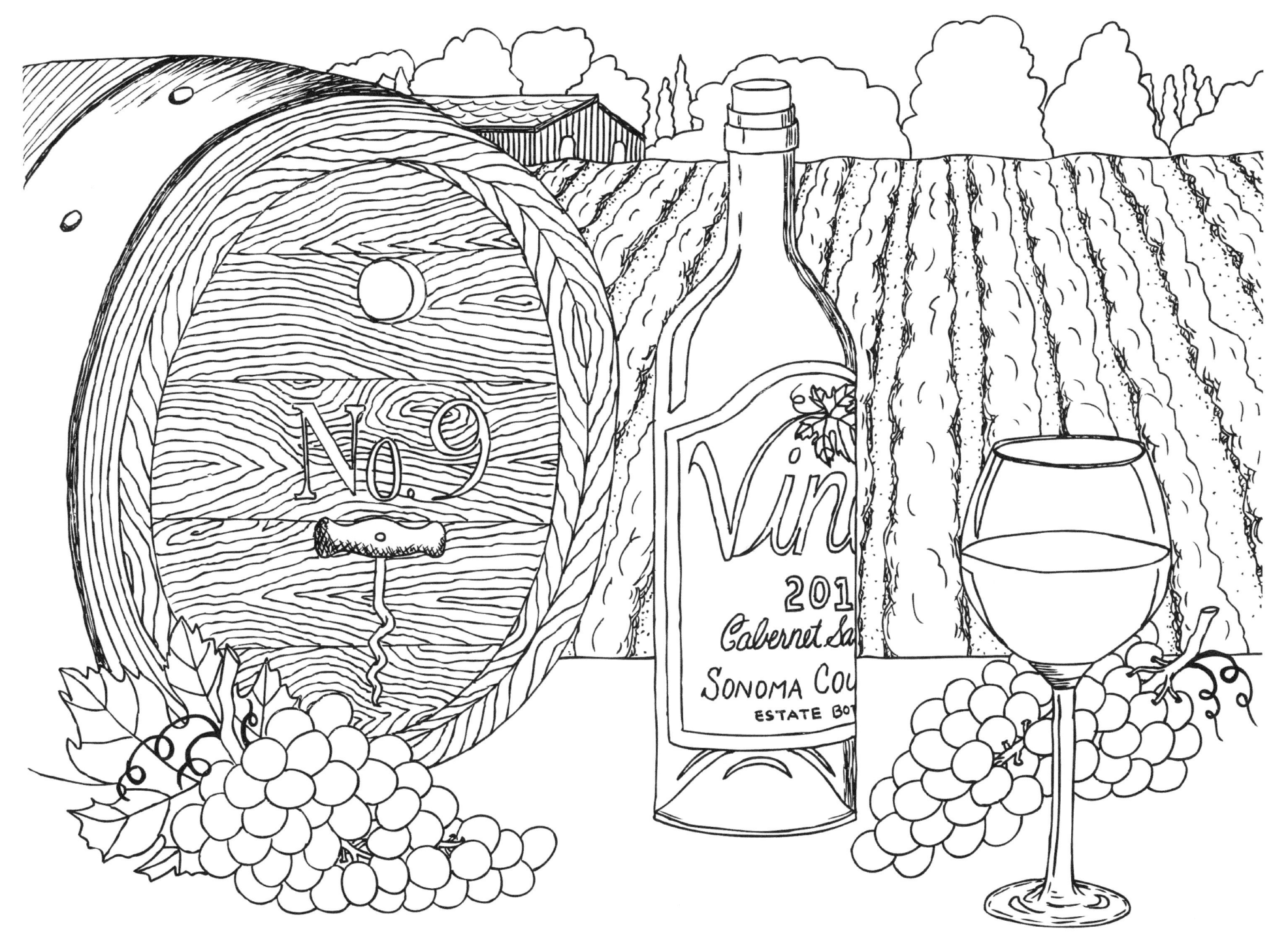

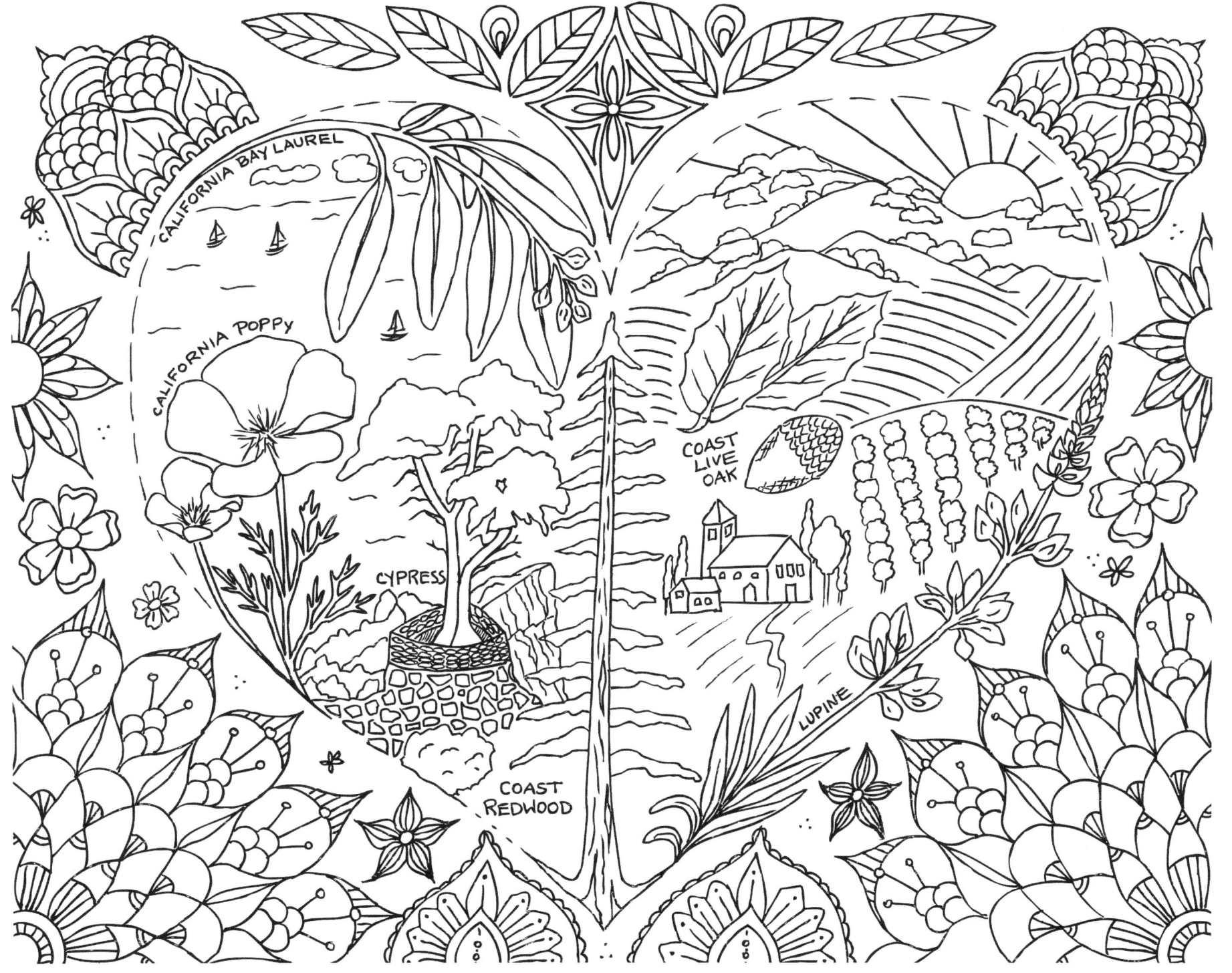

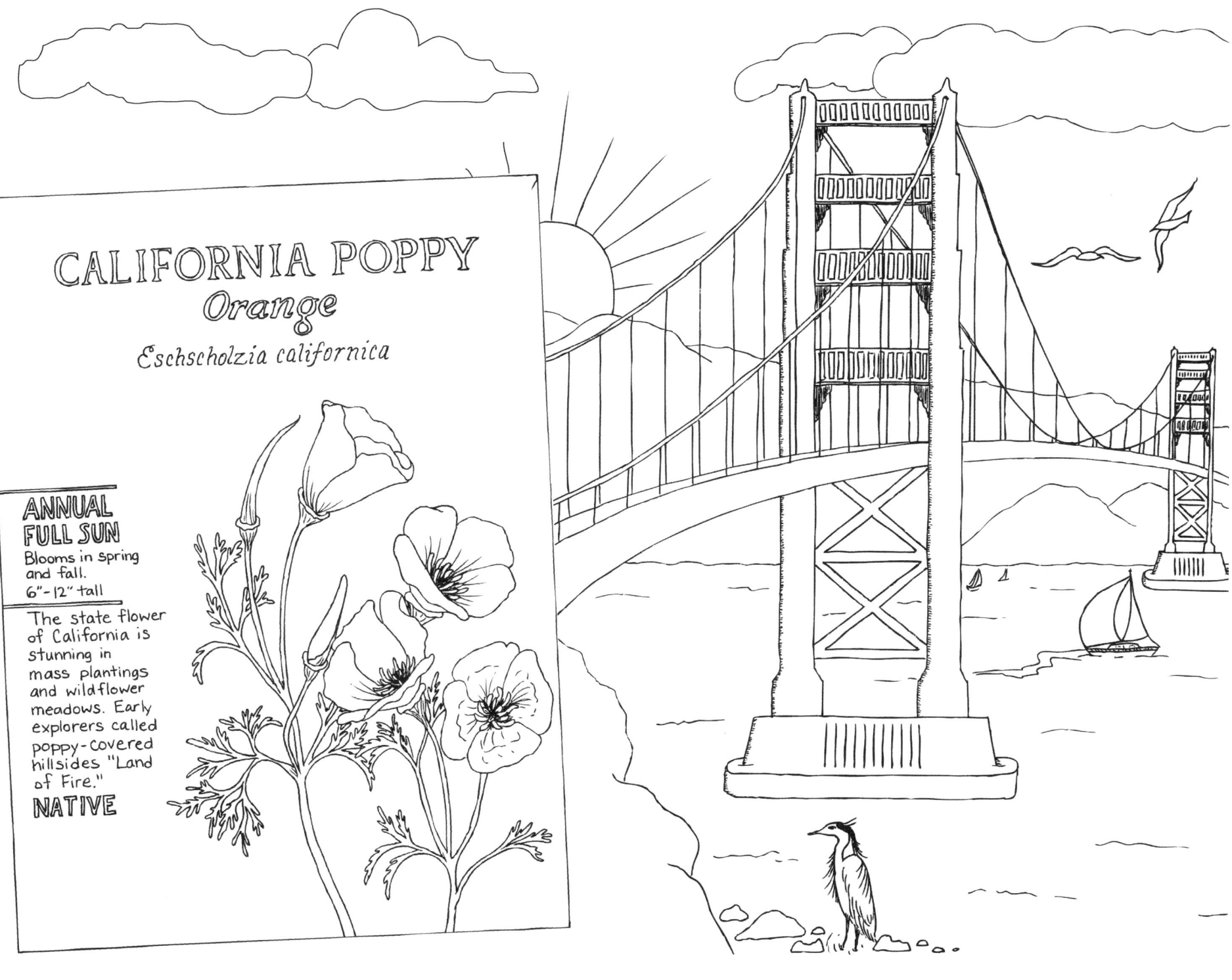

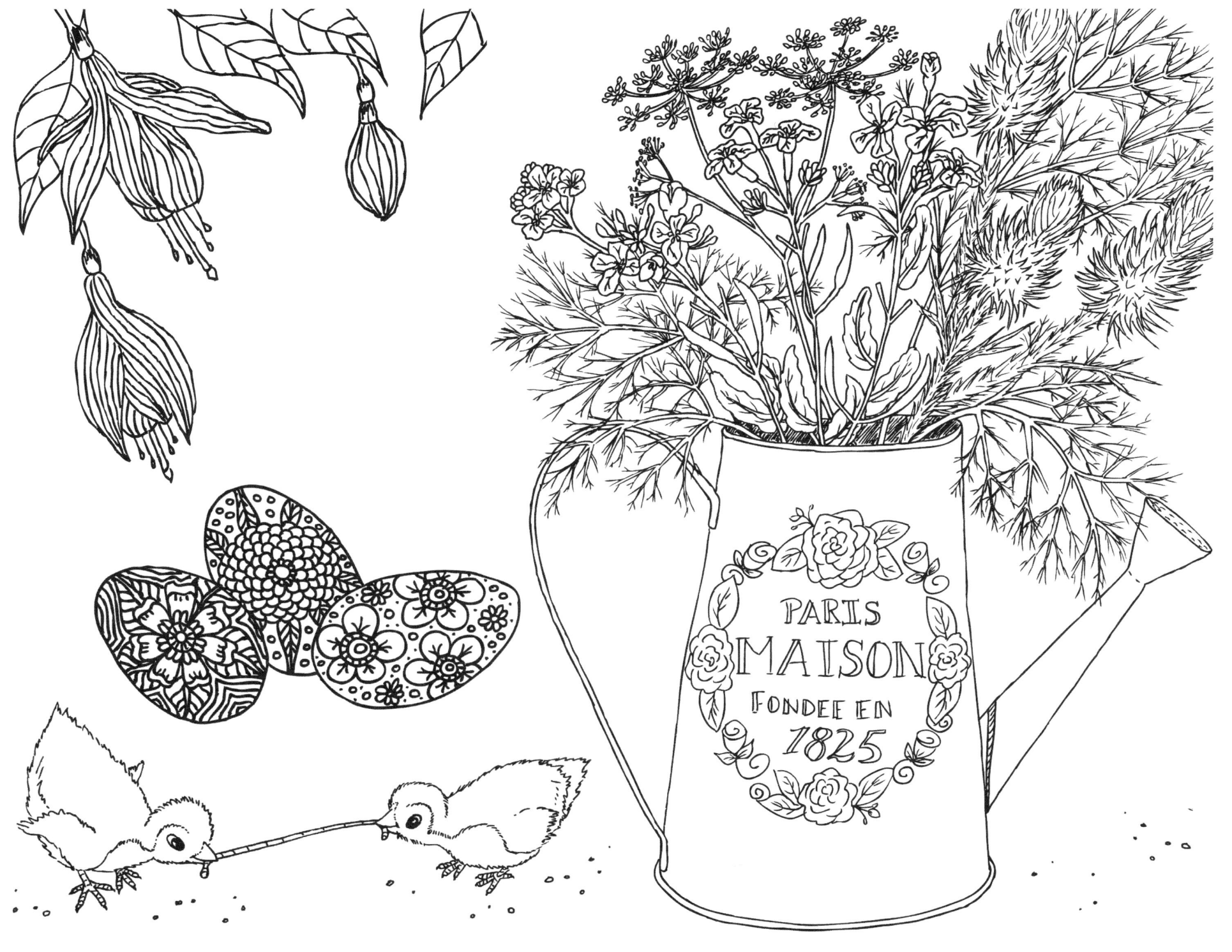

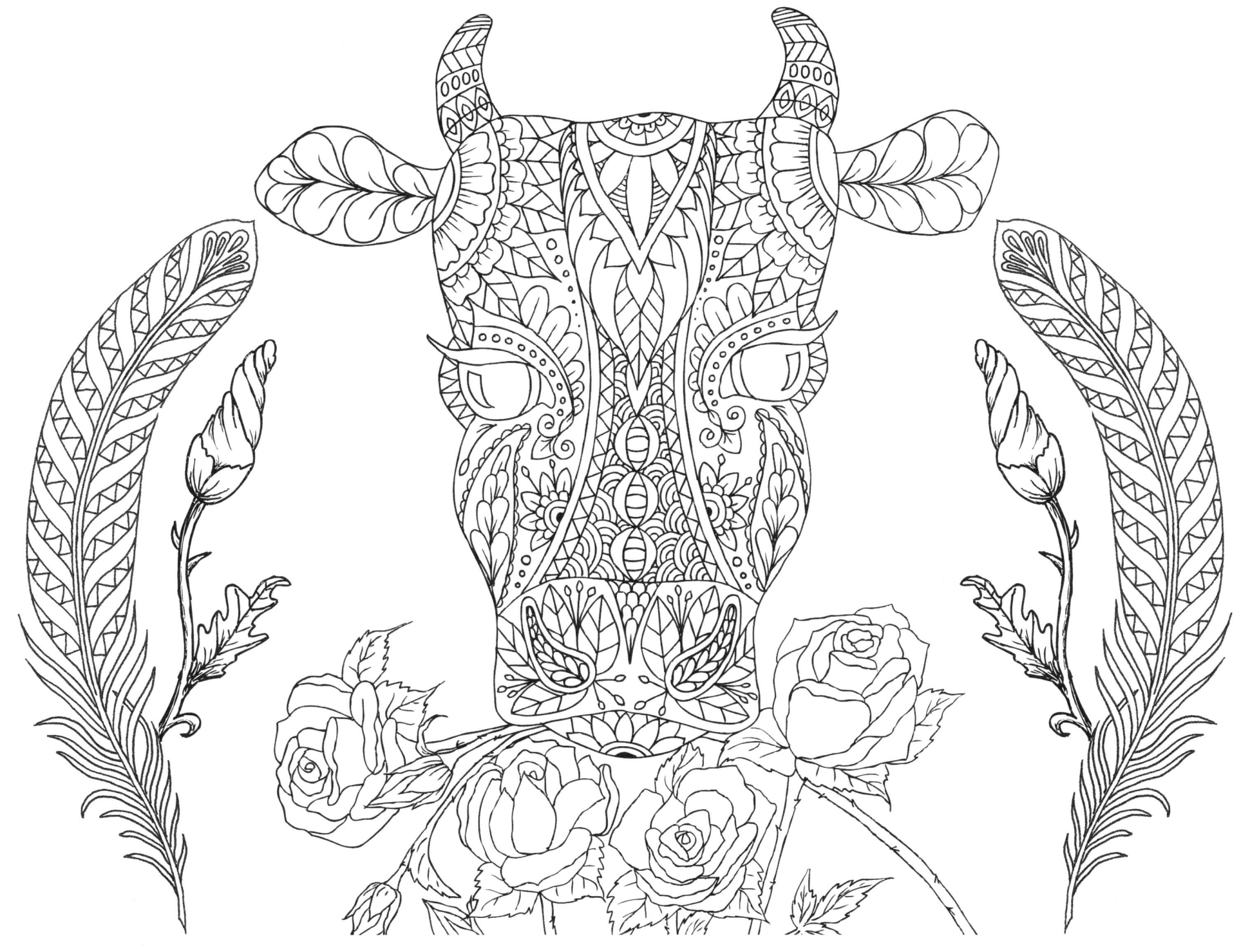

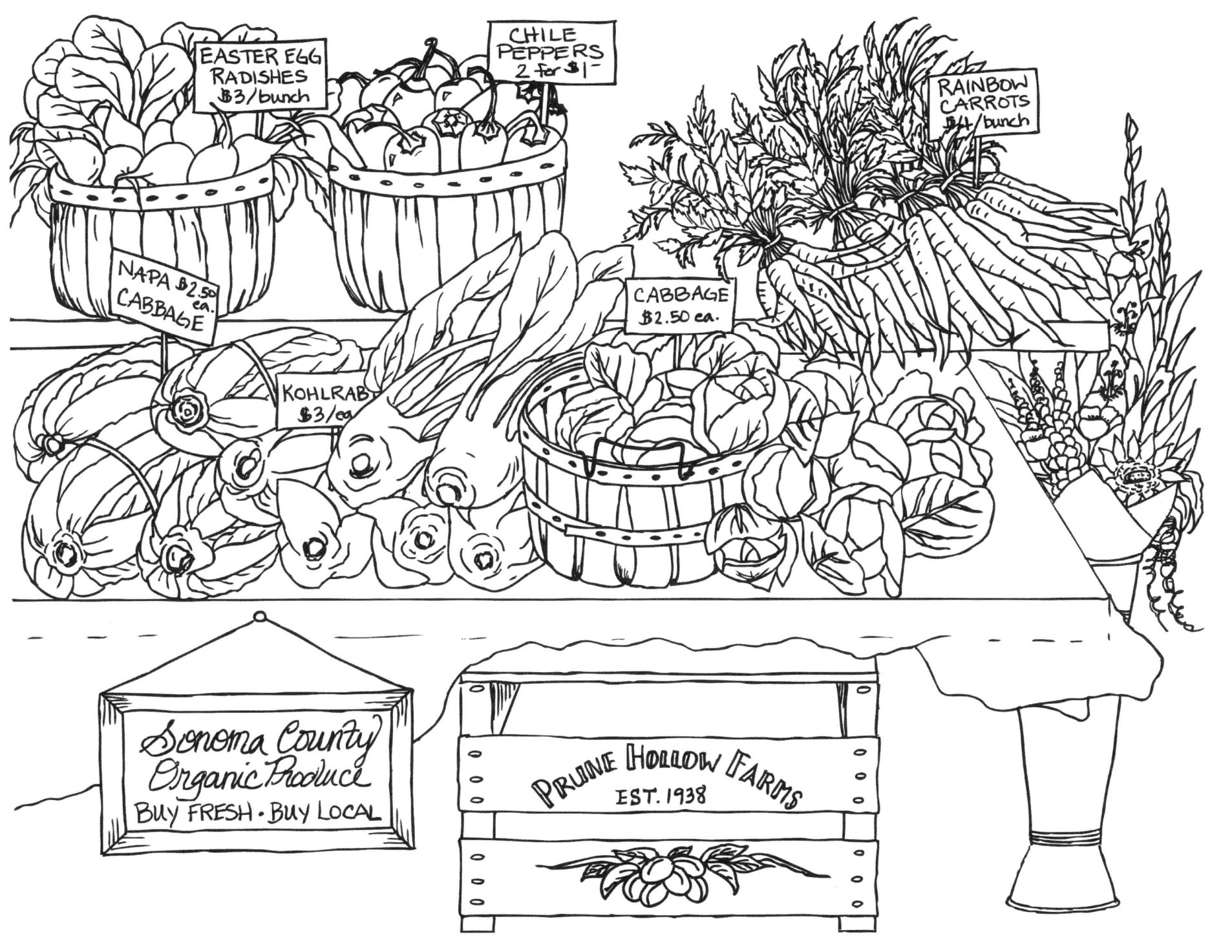

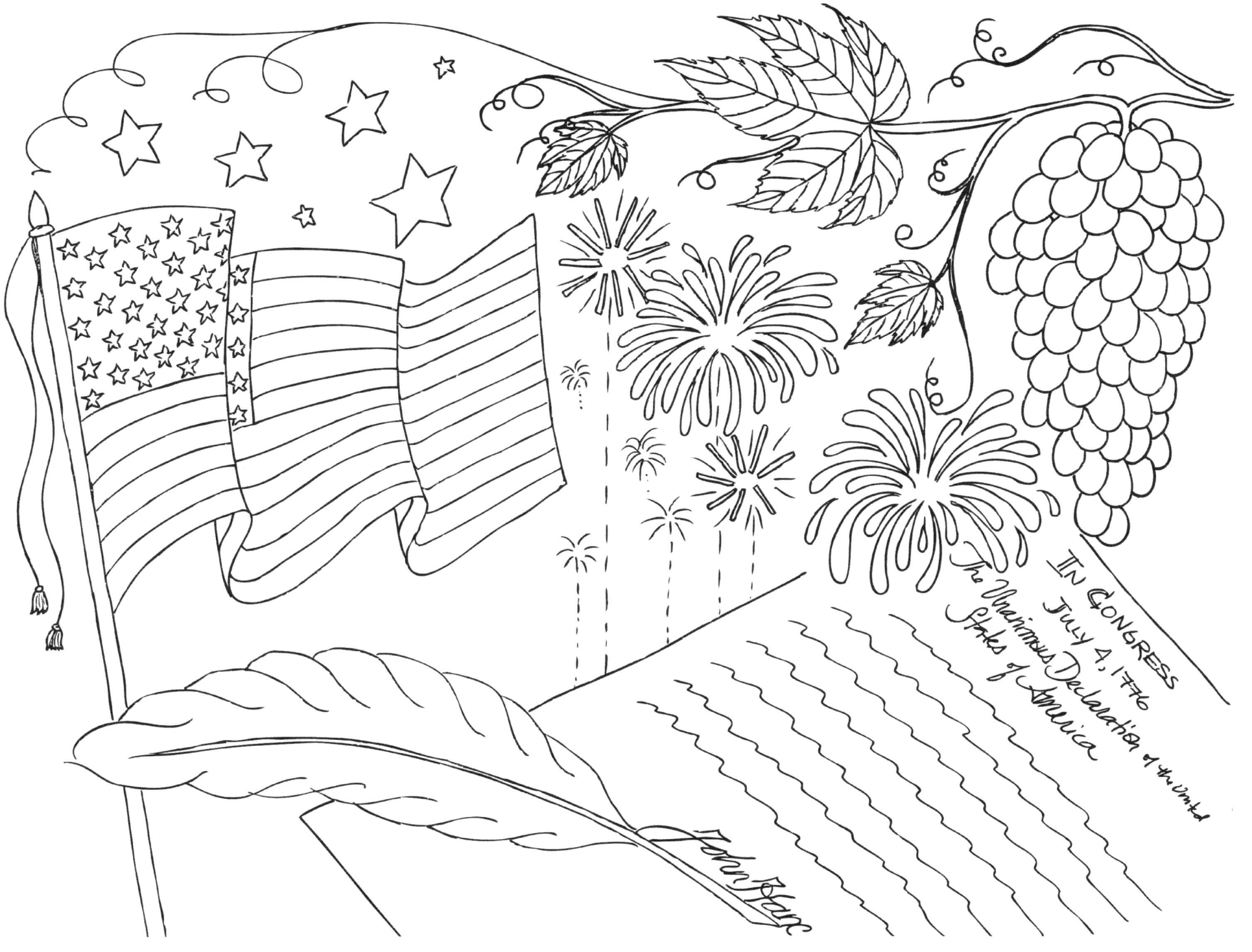

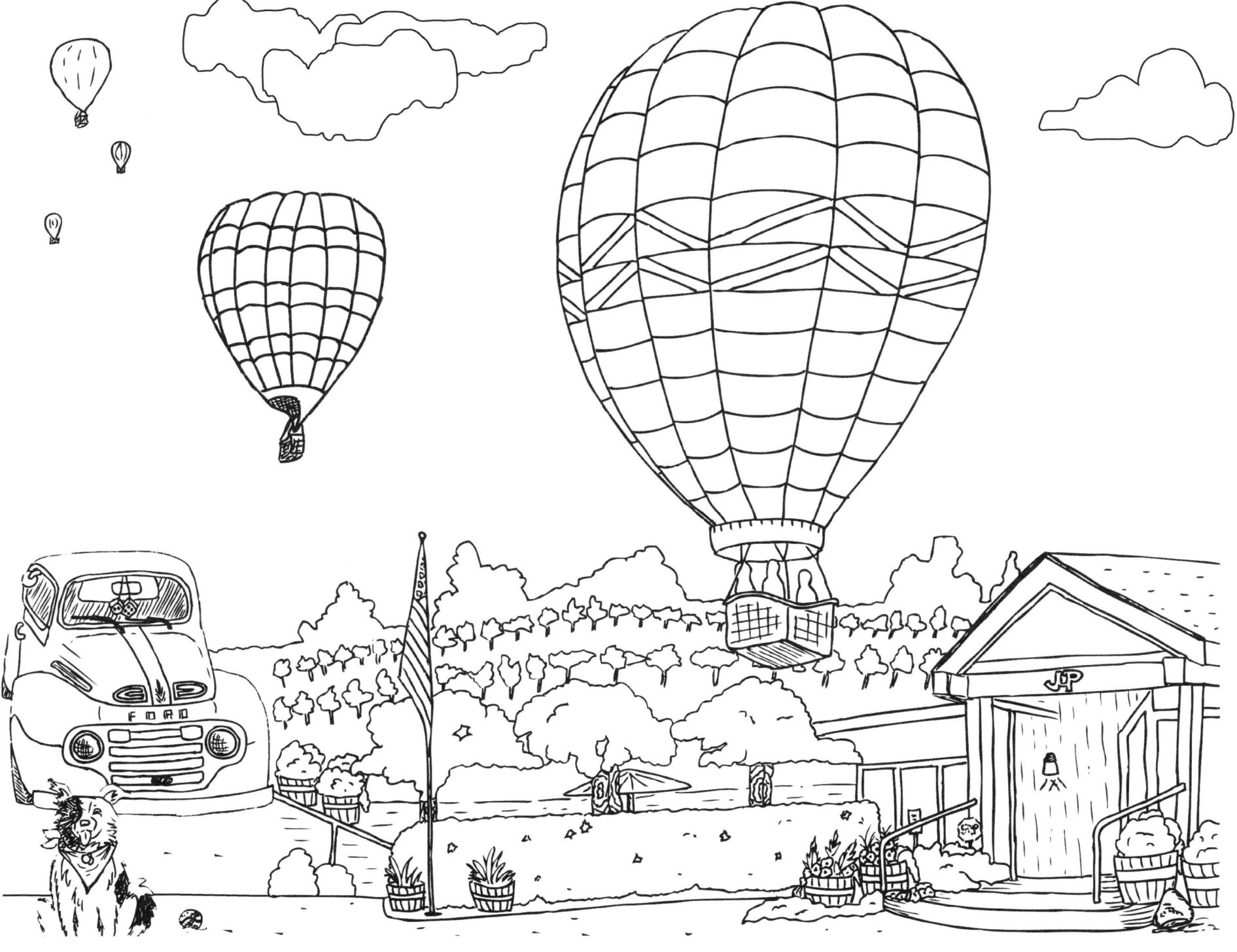

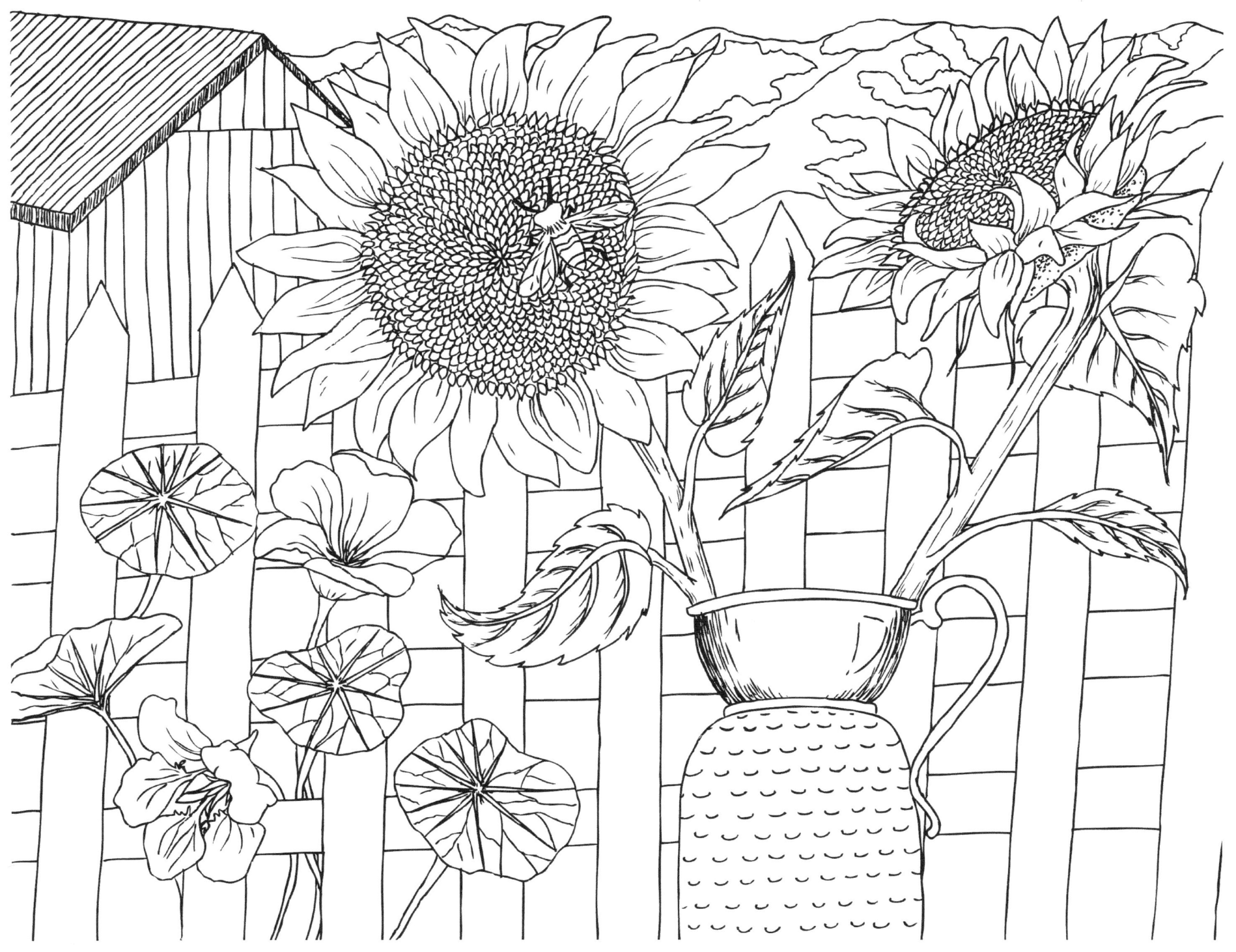

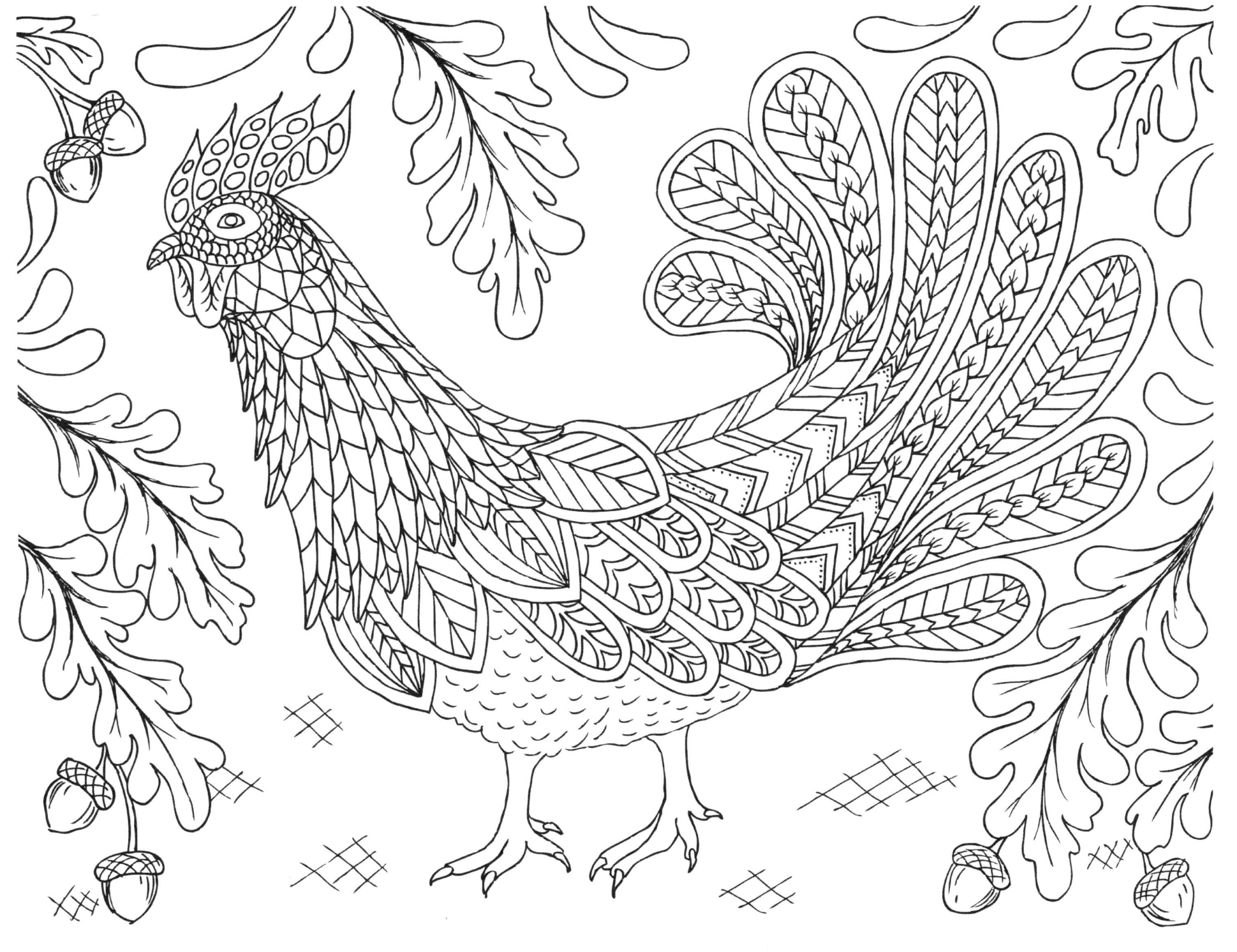

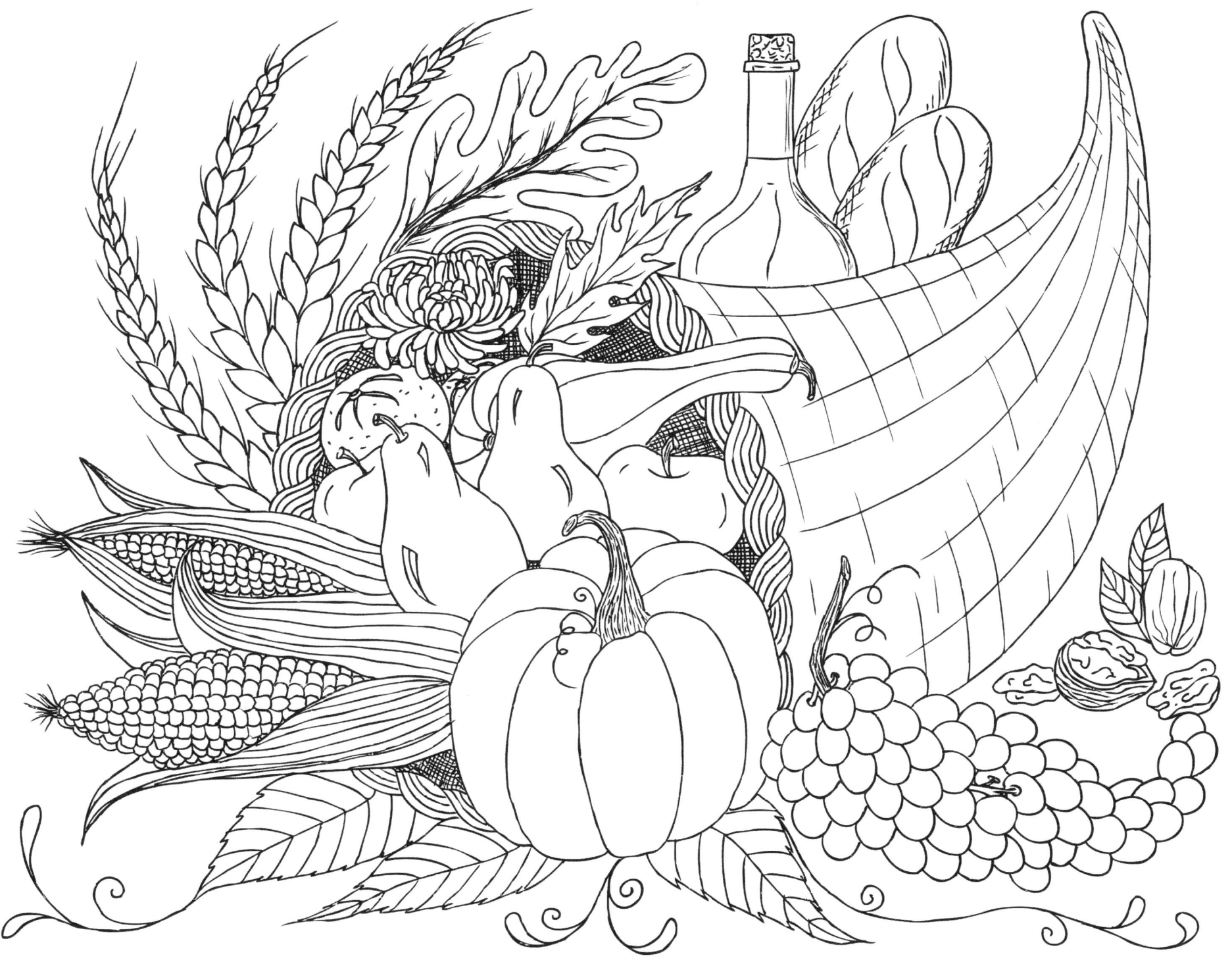

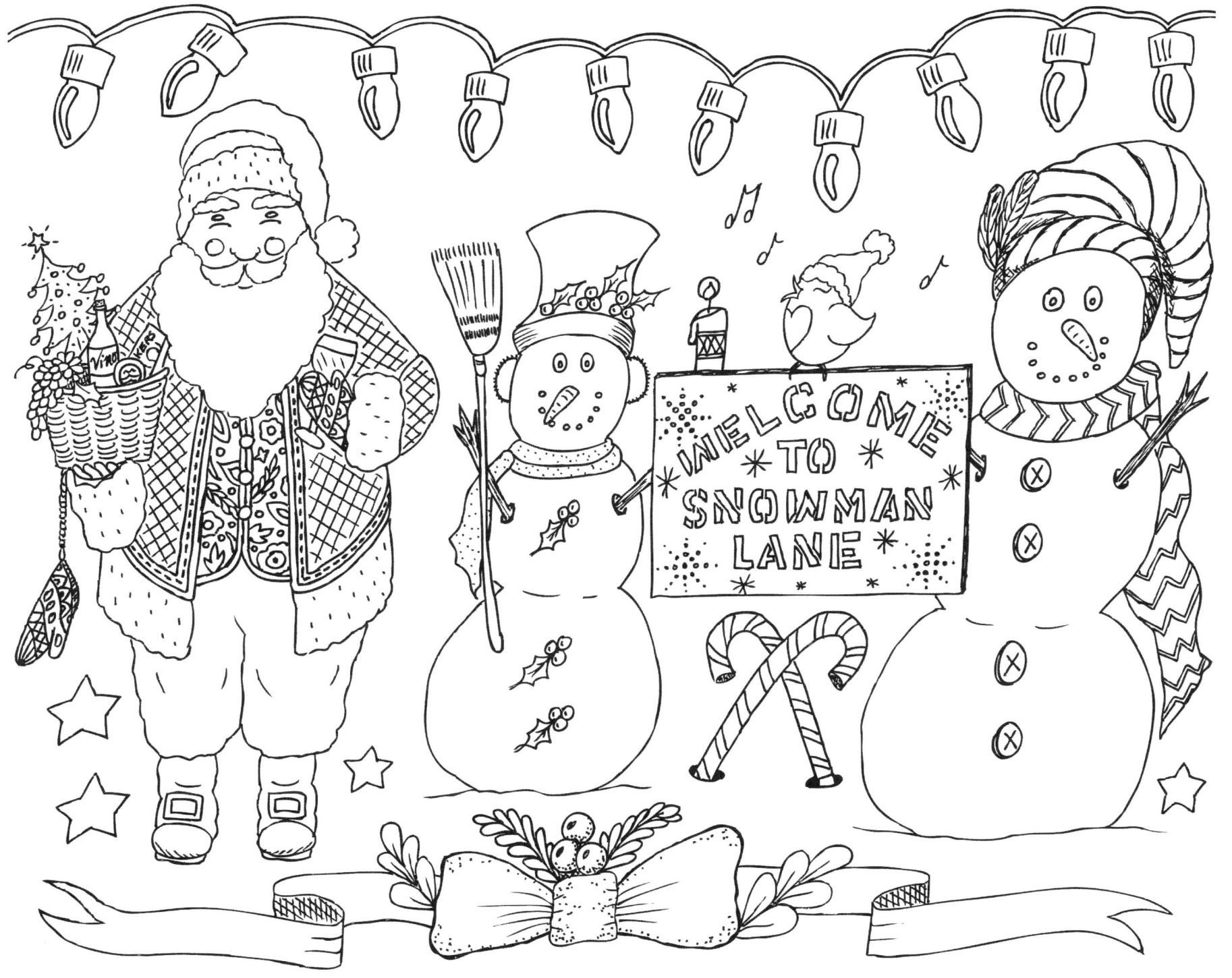

"COLORING FOR RELAXATION"
50 COLORING PAGES
FROM THE SAME ARTIST!

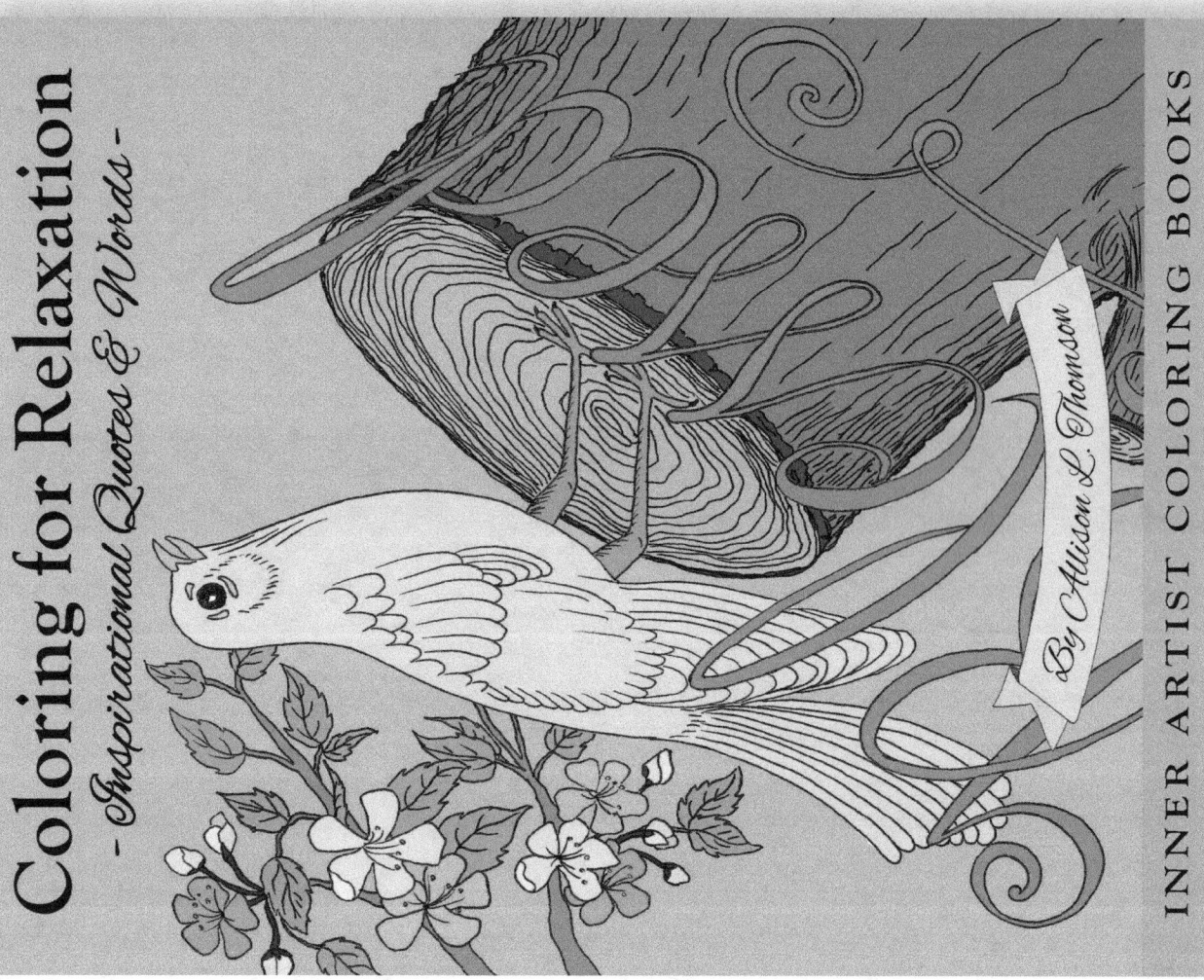

Coloring for Relaxation
- Inspirational Quotes & Words -

By Allison L. Thomson

INNER ARTIST COLORING BOOKS

Available on Amazon:
www.Amazon.com/Coloring-Relaxation-Inspirational-Quotes-Artist/dp/1530546265

And CreateSpace:
www.CreateSpace.com/6139577

INNER ARTIST COLORING BOOKS

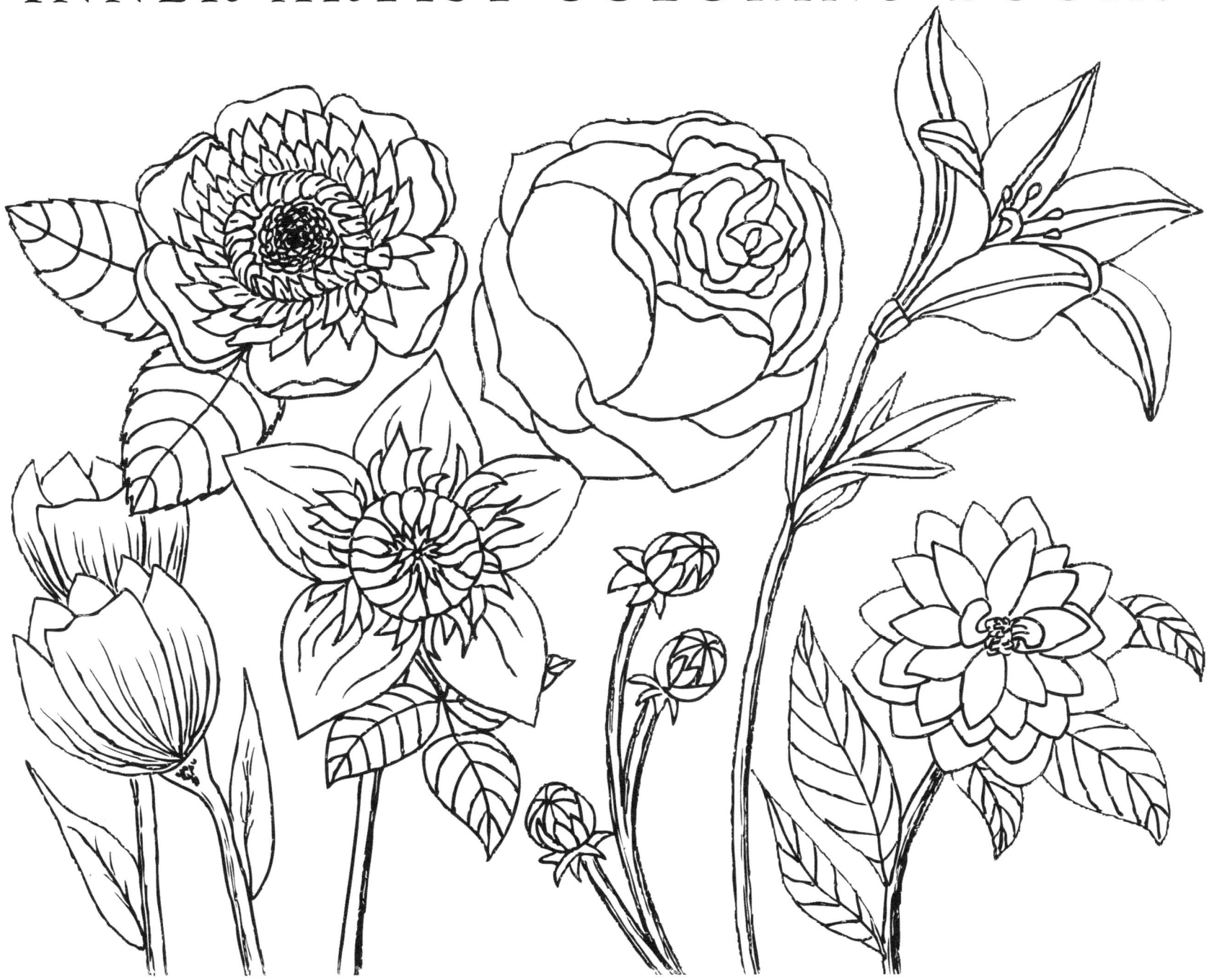

ALLISON L. THOMSON | WWW.FACEBOOK.COM/INNERARTISTCOLORINGBOOKS | INNER-ARTIST@OUTLOOK.COM